HIV POSITIVE

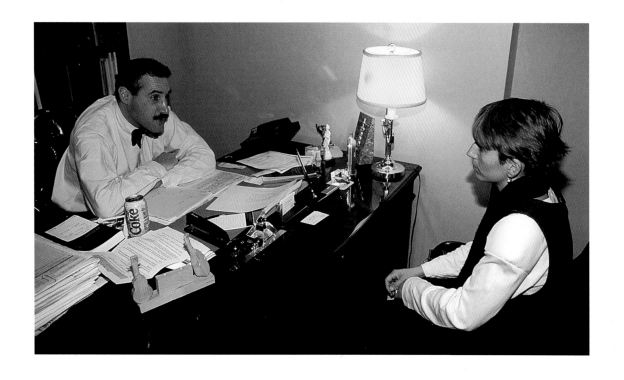

Bernard Wolf

DUTTON CHILDREN'S BOOKS • NEW YORK

THIS BOOK IS FOR SARA AND FOR HER SHINING COURAGE, HER HOPE,
AND HER LOVING HEART.

Library of Congress Cataloging-in-Publication Data
Wolf, Bernard, date.
HIV positive/by Bernard Wolf.—1st ed. p. cm.
Summary: Tells about AIDS through the story of a twenty-nine-year-old mother of two who has the disease.
ISBN 0-525-45459-4 (HC)
1. AIDS (Disease)—Juvenile literature. 2. AIDS (Disease)—Patients—Family relationships—Juvenile literature.
[1. AIDS (Disease)] I. Title.
RC607.A26W646 1997
362.1'969792—dc20 96-20974 CIP AC

Published in the United States 1997 by Dutton Children's Books,
a division of Penguin Books USA Inc.
375 Hudson Street, New York, New York 10014

Printed in Hong Kong First Edition
2 4 6 8 10 9 7 5 3 1

Acknowledgments

For their generous support and assistance in the preparation of this book, I wish to thank

the following persons: Donald Wolf, director of communications, GMHC, New York City;

Marianne Hardart, coordinator of Child Life programs, GMHC; Jacqueline L. Cohen, A.C.S.W.,

and Julie List, A.C.S.W., both with the Jewish Board of Family and Children's Services;

Eric P. Neibart, M.D.; Christina D. McCloskey, attorney-at-law; and my editor, Lucia Monfried.

Most of all, I am indebted to Sara's children, Jennifer and Anthony;

her sisters, Madeleine, Maria, and Nancy; and Sara's mother, Ramona,

for their understanding and hospitality.

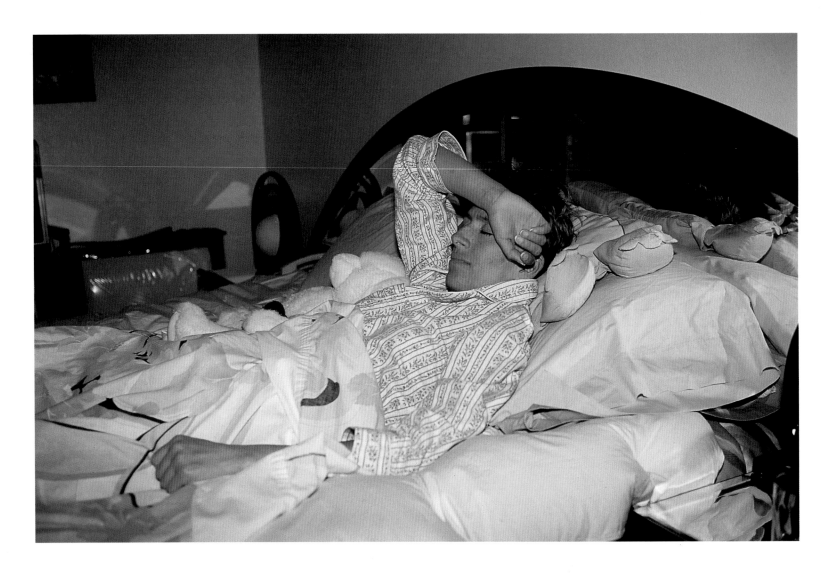

Sara is twenty-nine years old. She has two children: Jennifer, who is nine, and Anthony, who is six. Sara is a lovely, warmhearted young woman who has a sparkling sense of fun. She also has AIDS. Sara learned six years ago that she had the HIV virus. Now that virus has developed into full-blown AIDS.

Tonight is New Year's Eve. It's a special night for Sara. She wants it to be a happy night. But it will be hard. For weeks she has suffered from intense headaches, nausea, and a cough that has kept her from sleeping. This morning, she felt too sick to get out of bed. But tonight Sara is throwing a special party. So she gets up around six o'clock. The party is to celebrate the fact that she's still alive. All day long, her mother and sisters have been cleaning her apartment and preparing food for the many friends and relatives who will come.

Sara and Jennifer put makeup on their faces. Although Sara still feels weak, she is determined that tonight, everybody's going to have a ball!

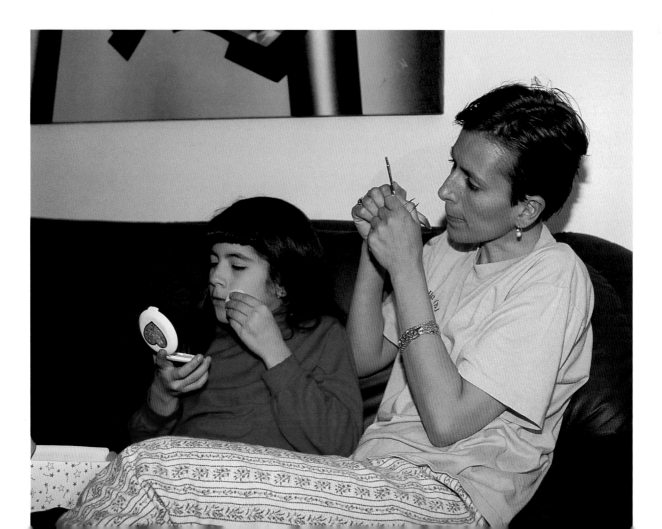

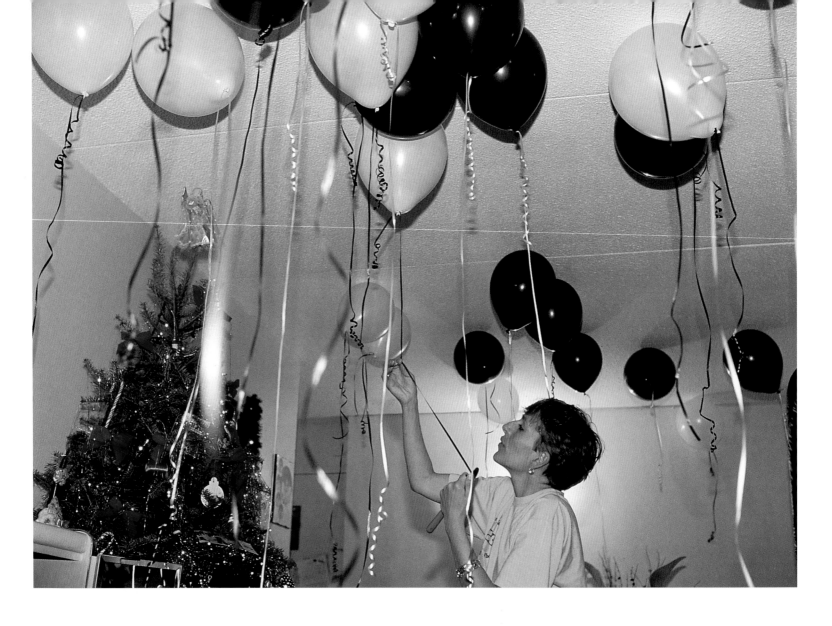

Jennifer helps her mother tie streamers to a bunch of balloons, and Sara floats them up to the living-room ceiling. Then they dress for the party.

At eight o'clock, the doorbell rings. Sara greets two of her cousins with hugs and kisses. She and her three older sisters have all decided to wear slinky black dresses tonight. The sisters—Madeleine, Maria, and Nancy—sit on a sofa with Sara draped across their laps for a group picture as the men whistle in appreciation. There is a powerful bond of love and support for their younger sister among these women. Sara's struggle for survival has touched their lives deeply.

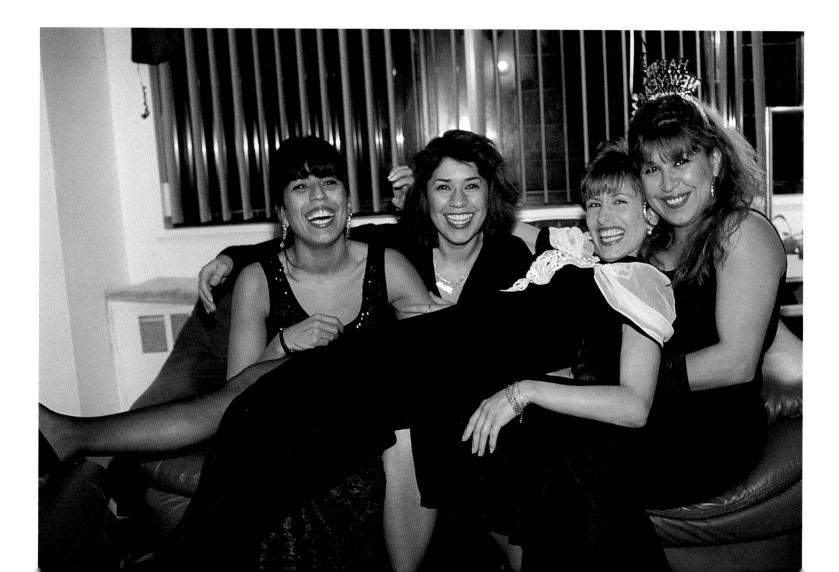

Jennifer's cousin Maggie sits with her while Jennifer carefully cradles Aunt Madeleine's newborn baby girl. At seven, Maggie is a bright and sensitive child, and the only young person to whom Jennifer has ever been able to confide about Sara's illness. These talks help Jennifer relieve some of her worries and fears.

But soon the music and laughter draw the girls back to the party. Sara and her mother, Ramona, are dancing in a close embrace, tears streaming down their cheeks.

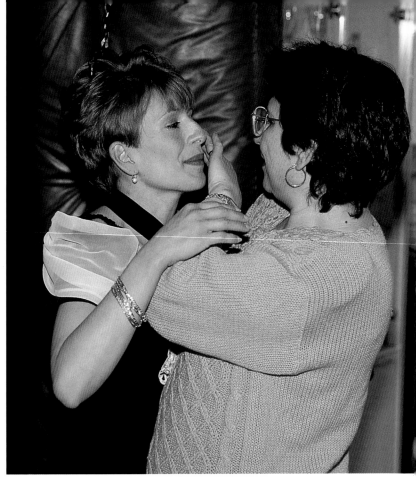

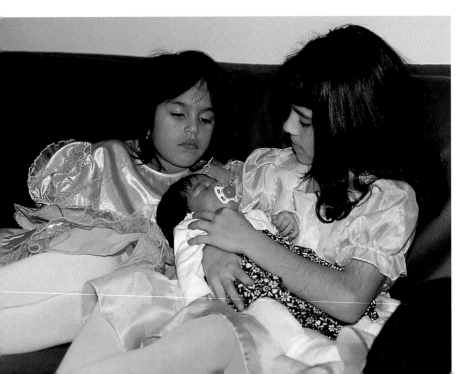

It was only five months ago that Sara lay on a hospital bed, just an hour from death. It was her third and most serious hospitalization for an AIDS-related illness. She had PCP (pneumocystic pneumonia), an often deadly form of pneumonia that attacks people with AIDS.

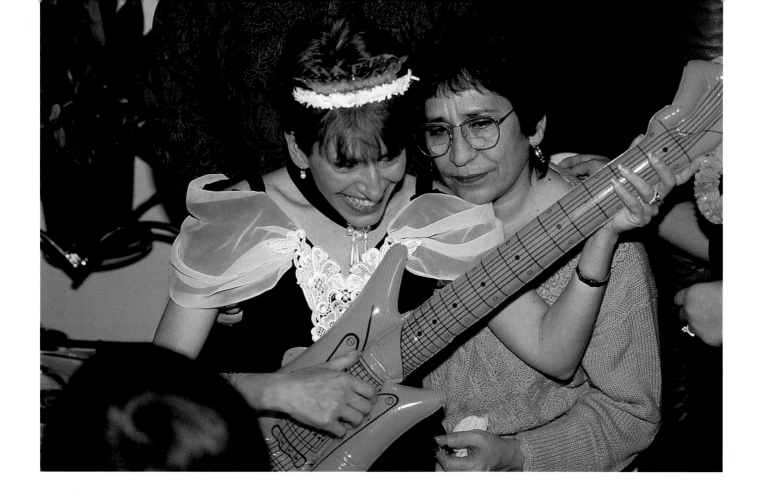

Sara's weight was down to eighty pounds, and she looked like a corpse. Each breath cost her enormous effort. Like many other AIDS victims in this situation, she wanted to die. The doctors pleaded for permission to put her on life-support systems, but she refused. She felt she had suffered too much. Almost too late, she changed her mind as she thought of her children's agony if she died. Sara told her doctor that she had decided to continue fighting for her life. Other doctors and nurses rushed into her room. Oxygen tubes were inserted directly into her lungs. A tube went into her stomach to supply liquid food, another to her legs to supply medication, and more tubes and wires to monitor and measure her heartbeat and oxygen blood levels. After seventy-two tense hours, the doctors were assured that Sara would survive—barely.

Sara forces these memories away as she dances in turn with Jennifer and Anthony. But Ramona cannot distance herself from this terrible threat to her daughter's life—even now, when everyone else is having fun.

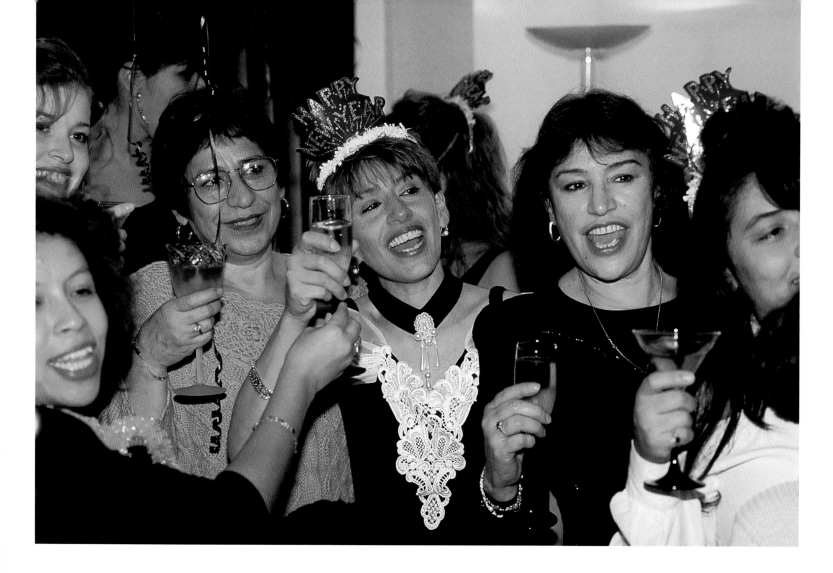

Someone turns on the television for the big countdown to midnight. Sara never touches alcohol, but tonight she makes an exception. She and her guests toast in the New Year with champagne. She has experienced one miracle in the old year. Perhaps, with luck, the coming year will bring her another.

For her and hundreds of thousands of others who suffer from AIDS, the biggest miracle of all would be a cure. Right now, there's none in sight. But Sara is a fighter. She refuses to give up hope.

A week later, Sara visits her doctor for an overdue checkup. Normally, she sees him every two months. When she's ill, she goes every two weeks. Now she's worried about her coughing, which has gotten worse.

Dr. Eric Neibart specializes in the treatment of patients with AIDS. First, he checks Sara's weight. She has gained six pounds! This shows that her body is getting the nutrition it needs, together with the medication she takes, to fight the HIV virus so she can become stronger.

After checking her heart and blood pressure, he carefully examines Sara's tongue and throat for signs of thrush. Thrush is a thick, white fungus that often grows in the mouths of AIDS victims. It is caused by bacteria, which often attack people with weak immune systems such as those who have AIDS or cancer. If untreated, thrush can seriously affect breathing and swallowing. Sara's mouth is clean. Dr. Neibart also can't find any soreness or irritation in her throat as a source of her coughing problem. He suspects that her coughing may be caused by some blockage of her sinuses, which is common in AIDS patients. But, to be sure, he wants his nurse to make chest X rays before Sara leaves.

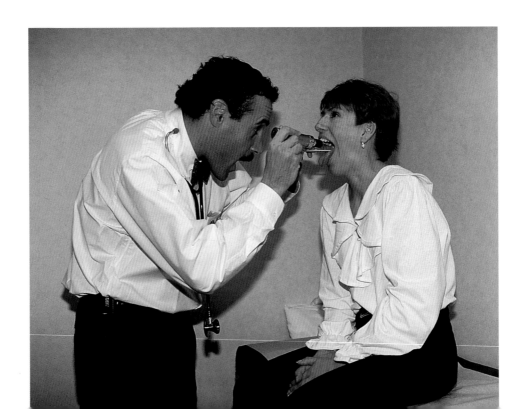

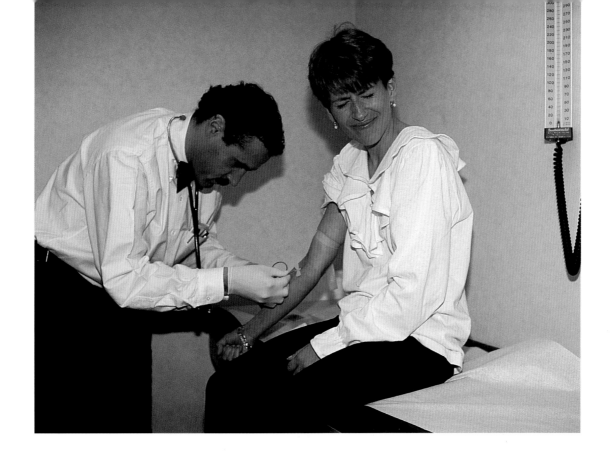

Next, he checks Sara's lymph nodes and spleen, and he pays critical attention to her eyes. Blindness is an all-too-frequent consequence of this devastating disease. A healthy person's body has an immune system that protects it against infection and disease. But the AIDS virus destroys the immune system so that gradually it can no longer fight off the kinds of illnesses that a healthy body can.

Finally, Dr. Neibart draws a sample of Sara's blood. This will be analyzed to see if her red- and white-blood-cell counts are normal. The white-blood-cell count is especially important. These cells are at the heart of the body's immune system; they protect the body against disease-producing microorganisms. If Sara's white-blood-cell level drops too low, she will become sick again.

All in all, Dr. Neibart has found nothing alarming at present, and he is pleased that Sara is doing so well. If her chest X rays are clear, he'll prescribe medication for her sinuses. He will see her again next week.

Each weekday after school, Jennifer and Anthony go to a community center, where they do their homework and play with other children in a place that is more relaxed than school. This also gives Sara extra time for herself and frees her for doctor's visits.

Jennifer is an unusually quiet and serious girl. She has no friends at the school she attends with her brother. She is afraid that if she told her classmates that her mother has AIDS, they would be frightened of her or mean to her. For most of her life, her mother has been very sick. Jennifer has had to look after not only her little brother but their mother as well, when she's been too ill to leave her bed. Jennifer is very close to her mother. Her greatest fear is that Sara may die.

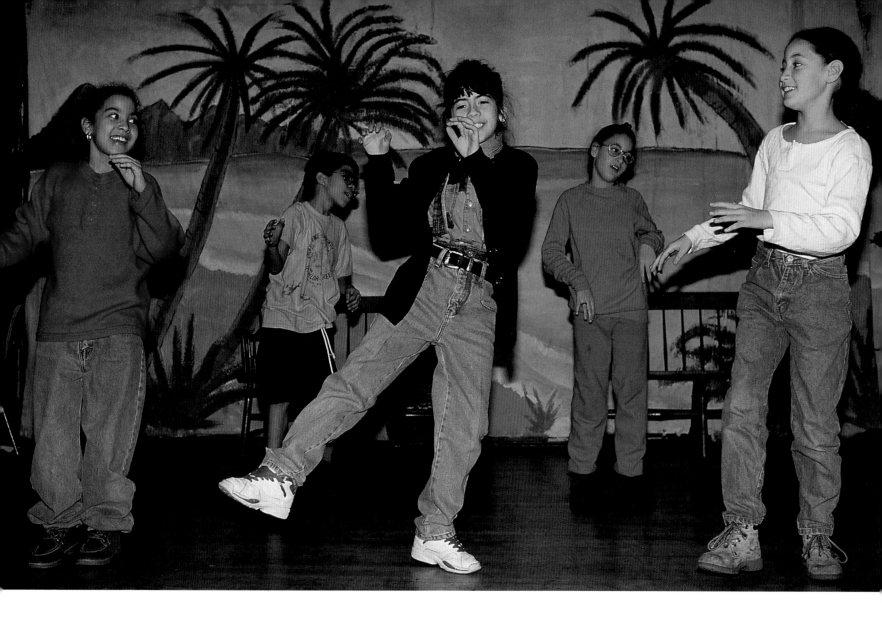

When her homework is done, Jennifer joins a group of children in a rehearsal for a show in honor of Black History Month. Jennifer loves music and dancing with her mother, but she doesn't get many chances to do this with Sara. She is also looking forward to the fancy dress and makeup she will put on for the show.

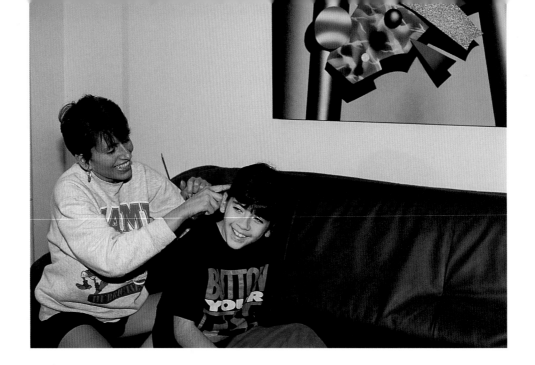

Before she became sick, Sara held a responsible, well-paying job with NYNEX, the New York Telephone Company. The company has an excellent insurance plan that gives lifetime coverage to employees who are unable to work because of a major injury or illness. Enrolling in that plan was the luckiest decision Sara ever made. Now she receives monthly payments from this policy plus complete medical coverage. Without them, she could never maintain her comfortable, two-bedroom apartment, pay all her bills, and support herself and her children.

Sara tries to give her children as much attention as her health allows. For them, Saturdays when Sara feels well are a special treat. They spend a lot of time together and with Fluffy, their toy poodle. But when Sara is sick, Jennifer has to look after her brother and try to keep him quiet.

Sara first became sick when Jennifer was seven. She began to lose weight and she felt dizzy, nauseous, and weak. Her body ached, and she had splitting headaches. When she tried to eat, she had intense diarrhea. Her hands and feet swelled up. Her beautiful long hair started to fall out in large clumps when she combed it. She had been diagnosed as HIV positive six years earlier. The HIV virus had hidden quietly in her body for seven years. In some victims, the virus remains quiet for twelve years or more before developing into AIDS.

Sara didn't want to frighten her children. At first, she told them she wasn't feeling well. But one year later, after her first hospitalization for PCP, she had to tell them the truth. Jennifer was terrified and asked her if she was going to die. Sara said that many people with AIDS did die, but no one could predict if or when that might happen. Jennifer asked who would take care of her and Anthony if Sara died. Sara told her that their grandmother would look after them.

How did Sara get such a terrible disease? For Sara, this was the most painful question. When she was twenty and beginning her third year of college, she fell in love with a fellow student. He refused to practice safe sex. Sara became pregnant and left school. But that was only the beginning of her troubles. Not until Anthony's birth did Sara discover, to her horror, that the young man she had given her trust to was an intravenous-drug user who had contracted the HIV virus. When he had sex with Sara without wearing a condom, his infected semen was absorbed into her bloodstream. That's how she had become sick. That is also how most women with AIDS become infected. At that point, Sara refused to have anything to do with him.

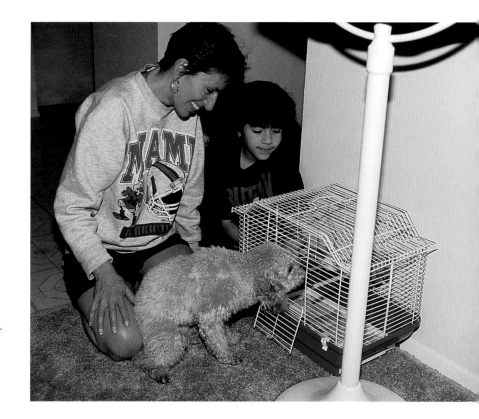

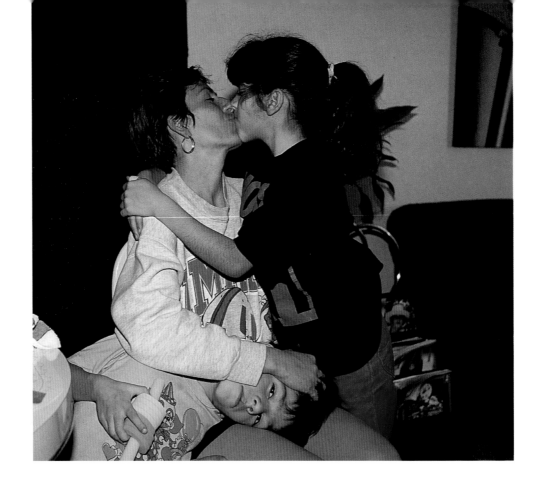

Jennifer was shocked to learn that her father was a drug user, and she was embarrassed by her mother's frank talk about sex. But Sara felt that her daughter needed to know these facts. Jennifer and Anthony had been tested for HIV, and they were both negative, which was a huge relief to Sara. Some infected mothers pass the disease on to their unborn babies.

Jennifer also wanted to know if she or Anthony could catch AIDS from Sara by touching or kissing her.

The answer was no. The only way Sara could infect another person would be through unprotected sex, or if she cut herself and her blood somehow entered someone else's body accidentally. But, Jennifer asked, wasn't there a really special medicine Sara could take to make her well? Unfortunately, no. That is what Sara and millions of others like her are praying for every day. Research is going on around the world to try to make that prayer a reality.

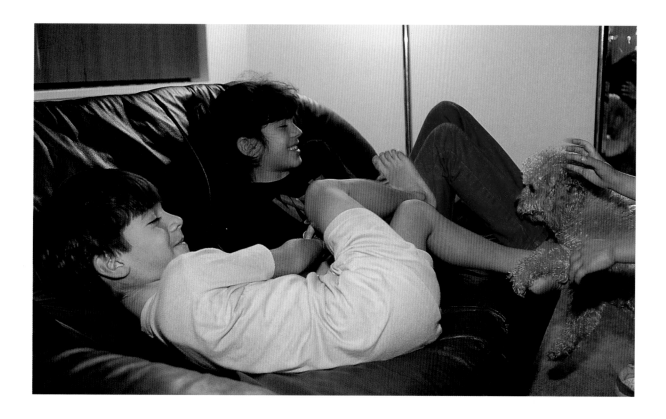

Each month Sara receives a bulletin from the Child Life program at the Gay Men's Health Crisis (GMHC). GMHC is a New York City volunteer organization that provides many services for people with AIDS, including a buddy system for those too sick to leave home, as well as legal, financial, and health-care assistance and family-support programs. Its Child Life program helps children who have AIDS or who live with AIDS-infected parents or family members deal with the many problems associated with this illness. Child Life is currently screening applicants for group therapy sessions for children seven to twelve years old and for their parents. Sara has decided to seek outside help for Jennifer and Anthony, and for herself as well. While the two children love each other, they have serious problems. Hardly a day passes without an intense argument erupting. Lately, this fighting has gotten worse.

On a cold Wednesday afternoon, Sara arrives with Jennifer and Anthony for an intake interview. They are greeted by three therapists—Marianne, Jackie, and Julie. First, the therapists ask the children if they know what HIV and AIDS are. Jennifer has a good grasp of her mother's problem, but Anthony understands only that his mother has a serious sickness. He seems restless and uneasy, so Marianne gives him paper and crayons to draw with.

Jackie asks how the kids get along together. Sara says they are constantly fighting. Sometimes the fighting, added to her worries about her illness, makes her feel desperate.

Jackie turns to Jennifer and asks who usually starts these fights. Jennifer is very nervous. Finally, she admits that she does. She doesn't know why. How are she and her brother doing at school? Jackie asks her. Sometimes, Jennifer says, she can't pay attention to her teacher. Anthony acts up a lot in class. Have they ever told their classmates that their mother has AIDS? The answer is no—they are afraid to. Sara says that once, when she was very sick, she got a note from Jennifer's teacher asking to see her. Sara sent her sister Madeleine in her place. The teacher was worried about Jennifer. Her grades were poor, she hardly spoke to any of the other children, and she often broke into sobs at her desk. When the teacher asked her why, Jennifer replied that her mother was sick and she wanted to go home to take care of her. Madeleine didn't tell the teacher that Sara had AIDS. She felt that no one in Jennifer's school would be understanding or sympathetic toward Sara or Jennifer. Instead, she said that Sara had breast cancer.

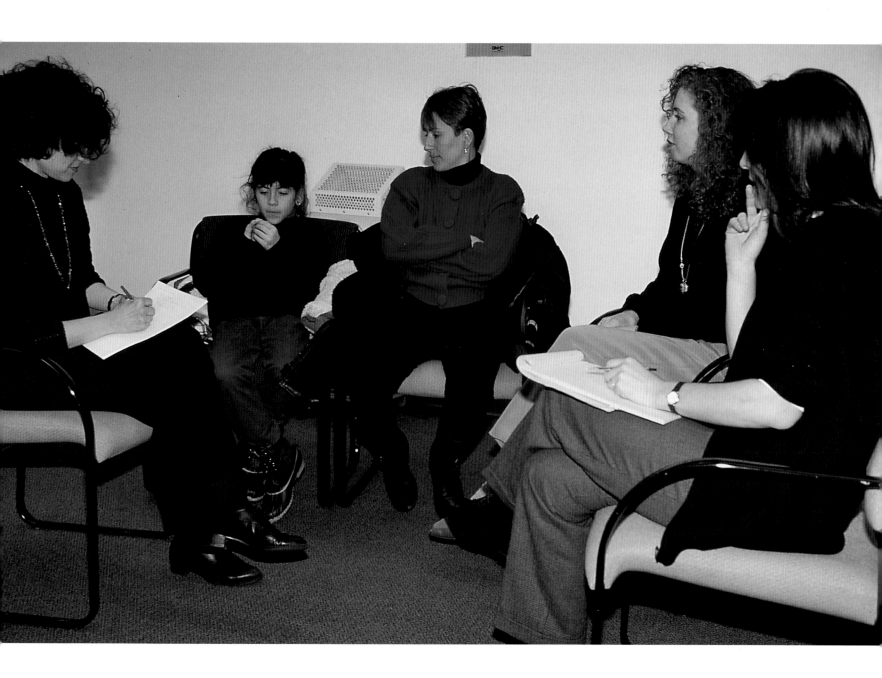

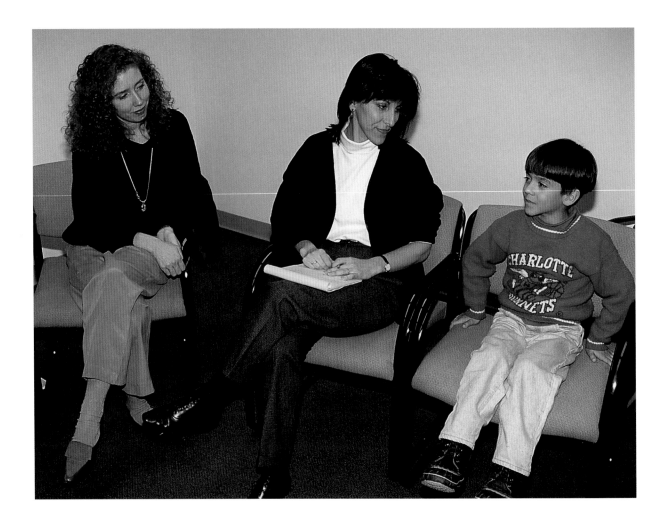

Marianne asks Anthony to join the others. Why does he think he and his sister fight so much? He answers that she is always trying to boss him. If he doesn't do what Jennifer wants, she hits him, but then he hits her back. He doesn't want to be her slave.

When asked, both children reply that they are really scared that Sara may die, but they have never discussed this with anyone outside the family. Marianne says it would help them to hear about the same fears and problems of the other children who will be joining their group.

While Sara remains with Julie, Marianne and Jackie take the children to separate rooms. Jackie asks Jennifer to draw a picture of her family. In her drawing, Jennifer shows herself, Sara, and Anthony with big smiles on their faces. But Anthony is standing on a mound, so he appears as tall as his mother and sister. Jackie asks her what the mound means. Jennifer explains that if Anthony were bigger, she wouldn't have to take care of him anymore. She's tired of looking after him, of walking him to school, to the community center, and then home. She's tired of always holding his hand when they cross the street. Sometimes he runs away from her. If something happened to him, it would be her fault. She doesn't want to be responsible for him anymore. Jackie then asks if she feels responsible for anyone else. Yes, she feels responsible for her mother. Jackie believes that Jennifer fights with her brother because this is the only way she knows to release some of her fear, resentment, and anger.

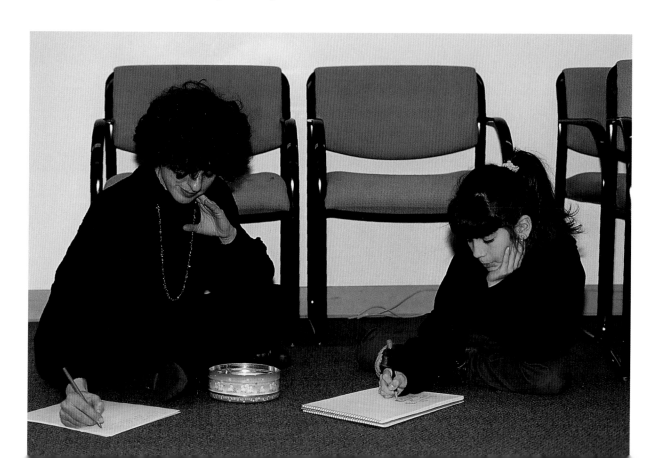

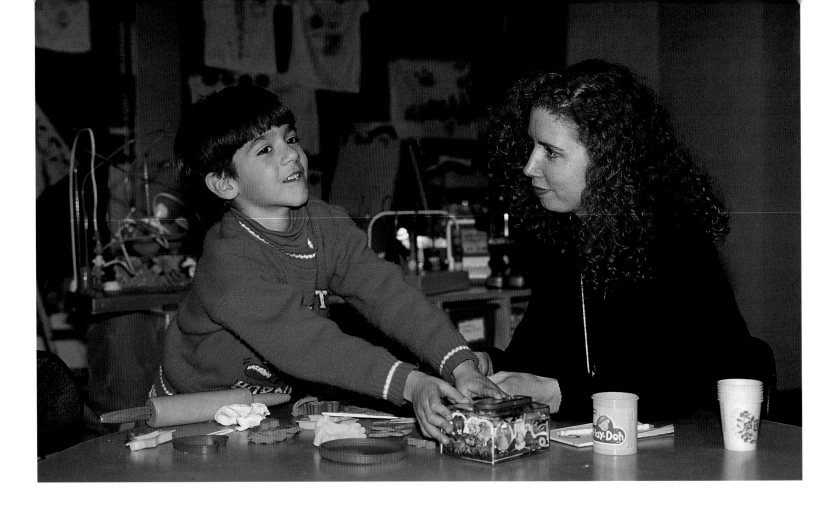

In another room, Marianne has given Anthony some clay to play with while they talk. If he had three wishes that could come true, what would they be? Anthony can think of only two. He would like lots and lots of money and lots and lots of toys. What would he do with the money and toys? He says he would share them with Jennifer, but he doesn't mention his mother. Marianne believes that this is because he feels too frightened by Sara's illness but doesn't know what to do about his feelings.

It's clear to the three therapists that Sara and her children badly need to share their fears and problems with others who are hurting as deeply as they are. It will help them to know that they are not alone. They agree to begin weekly group sessions next month.

Sara tries to make her children's lives as normal and happy as possible. As she and Jennifer cut up potatoes together to make French fries, it's hard for her not to feel guilty about the many times she's been too sick to give them the attention they needed. She's also worried about the problems they are having. Sara tries to make up for all the times she's been sick by doing things with her children when she feels well.

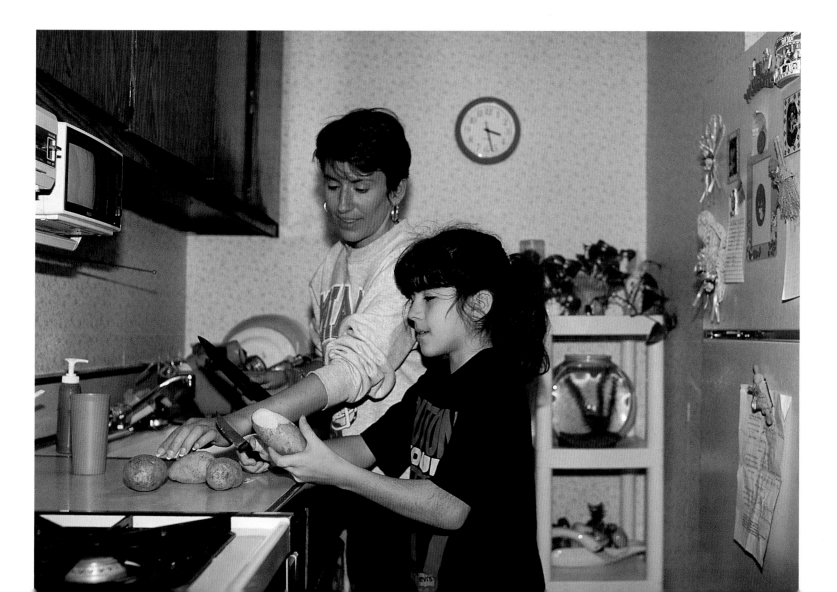

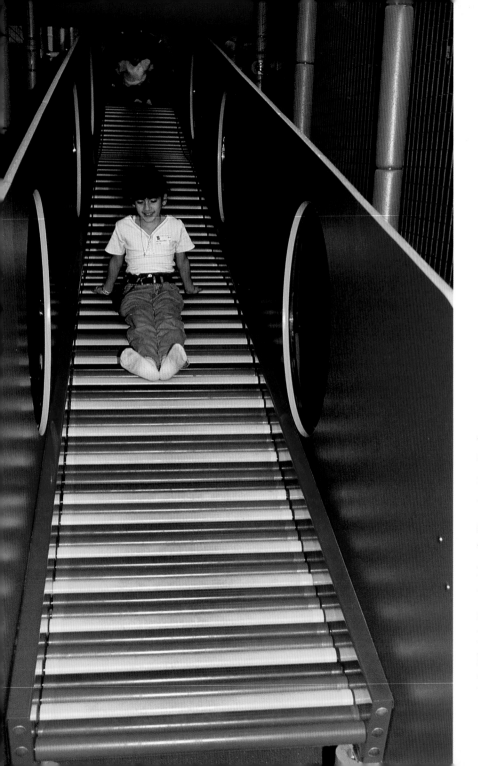

On a Saturday, Sara and her sisters take Jennifer, Anthony, and their cousins, Maggie and Johnny, to a shopping mall on Long Island. The mall has a big indoor playground with lots of exciting things for kids to do. Anthony zips off to explore the terrific video games. Jennifer whooshes down the long roller slide with Maggie and Johnny far behind. Then the kids fight their way through the "perilous maze." While they play, Sara and her sisters catch up on the events of the week. Later, everyone gobbles hamburgers with French fries and Cokes. Before heading home, Sara buys a new parakeet to try to mate with the one she has at home. It's been a fun day!

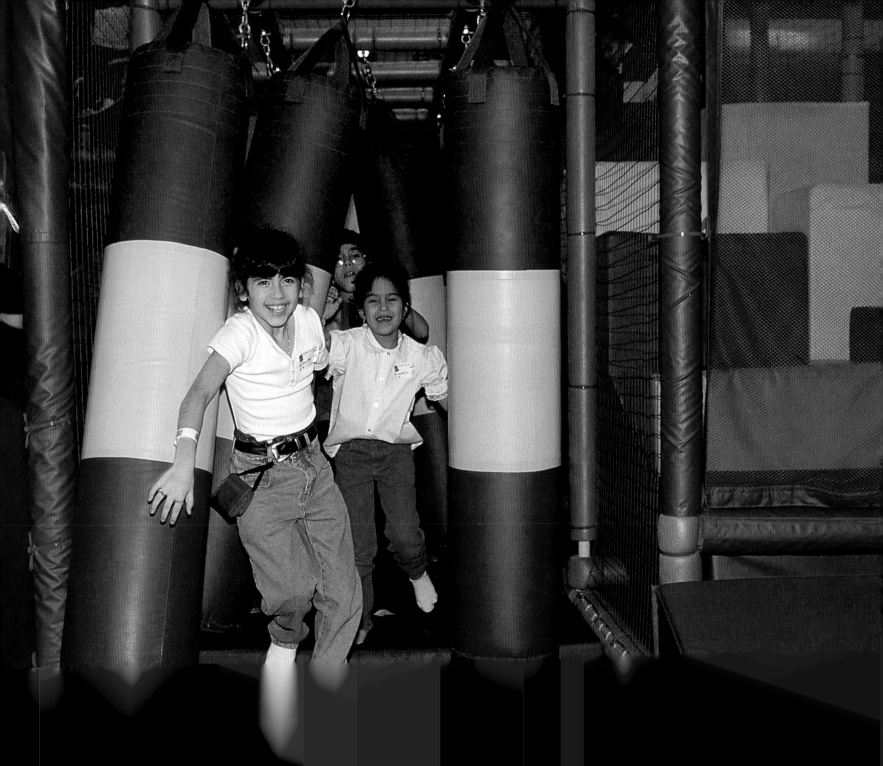

When she can, Sara takes care of the house while the children are at school. She washes and irons a big load of their clothes. She can't stand a speck of dirt on herself, her children, or anywhere in her home.

Lately, Sara has been feeling so well, she can hardly believe her luck. The sinus medication Dr. Neibart prescribed has stopped her coughing, and the other eight medicines she takes twice each day seem to be working effectively. She feels much more energetic, and she's sleeping soundly. She is almost back to her normal weight of 112 pounds!

But Sara is a realist. She knows that all this could change without warning. For years, a silent battle has been raging within her body. The AIDS virus is like a vast, invading army whose sole purpose is the destruction of all opponents. Sara's body produces ten billion of these deadly microorganisms every day, while it can produce only one billion white blood cells to combat them. The medications she takes seem to be slowing the invaders' advance, but there are no drugs that can completely halt it. Right now, Sara's white-blood-cell count is good. But the virus has a cunning intelligence. It protects itself by producing new strains to overwhelm the drugs currently available. These can help her go for months without a problem. But then suddenly, she can become sick again! Sara feels as if she is living on borrowed time.

Sara loves to talk on the telephone. Her sisters tease her, saying that without her support, NYNEX would go broke. Sara badly misses her job with that company. She would really like to get another job, but she is afraid that if she tells an employer that she has AIDS, she won't be hired. From her own bitter experience, she knows how so many people's ignorance can lead to fear, prejudice, and cruelty. When she told her coworkers that she was infected with HIV, some asked to have their desks moved far from hers. Others stopped talking to her. People she thought of as friends would have nothing to do with her. Sara is also afraid of what might happen if she got sick again while working at a new job. And there's another catch: if she *did* go back to work now, she would lose both her health and disability insurance plans, and she doesn't know what she would do without them.

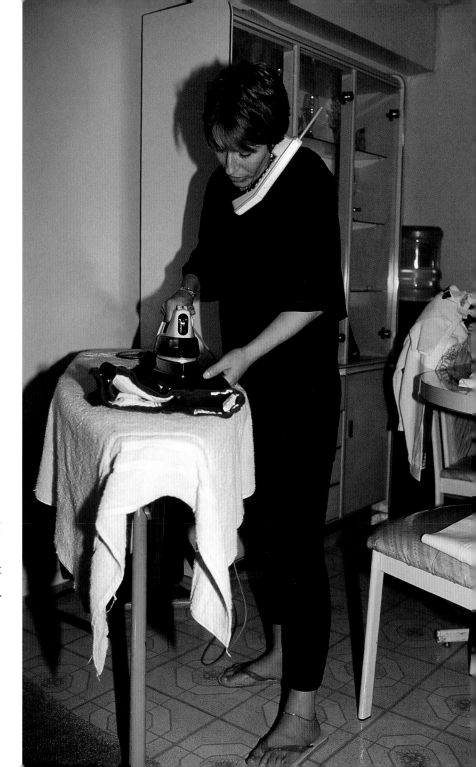

A little past six o'clock, Jennifer comes home from the community center with Anthony and their cousin Johnny. As soon as he's inside, Anthony tears off his jacket and throws it on the floor—as usual. Then she fixes him a bowl of cereal, and listens while he com-plains that Jennifer won their race home only because she tricked him! Jennifer just laughs.

Sara tells him that it's not a good idea to throw his clothes on the floor.

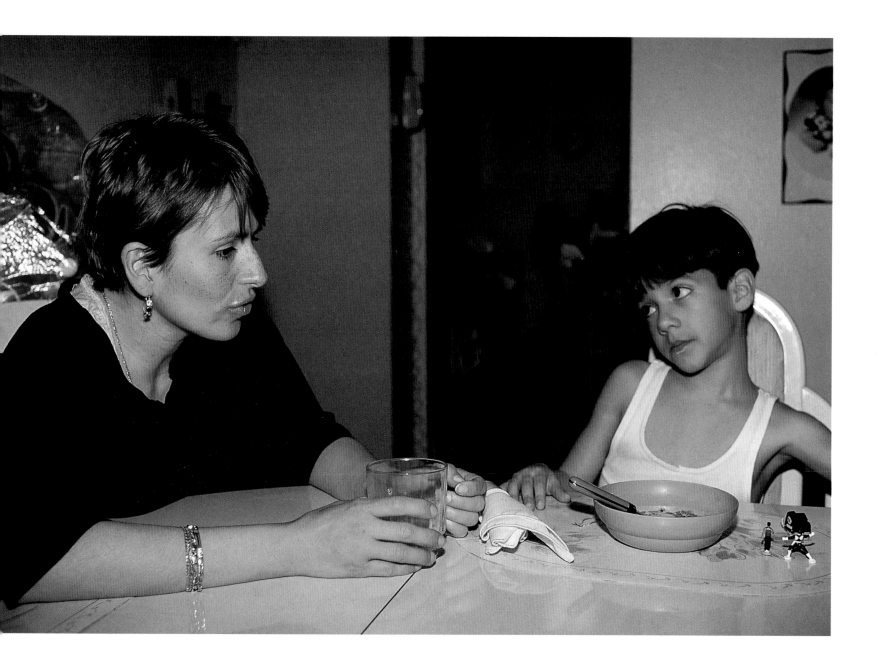

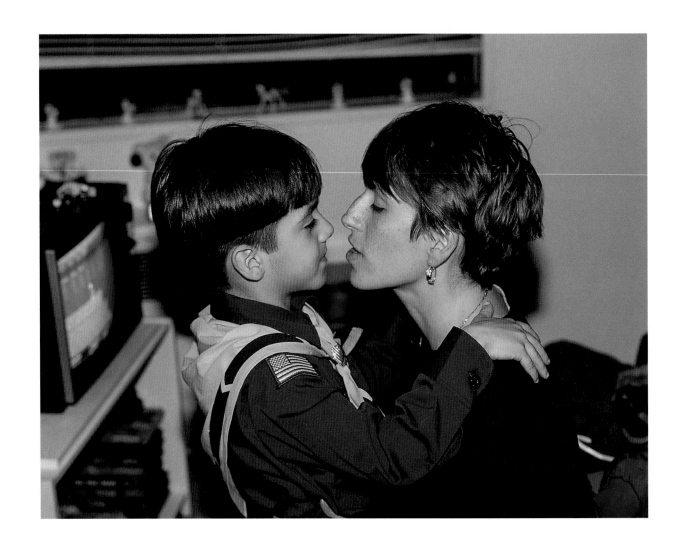

Sara reminds him that he has a Cub Scout meeting
this evening and he needs to put on his uniform quick-
ly. His aunt Madeleine will be here any minute to pick
him up.

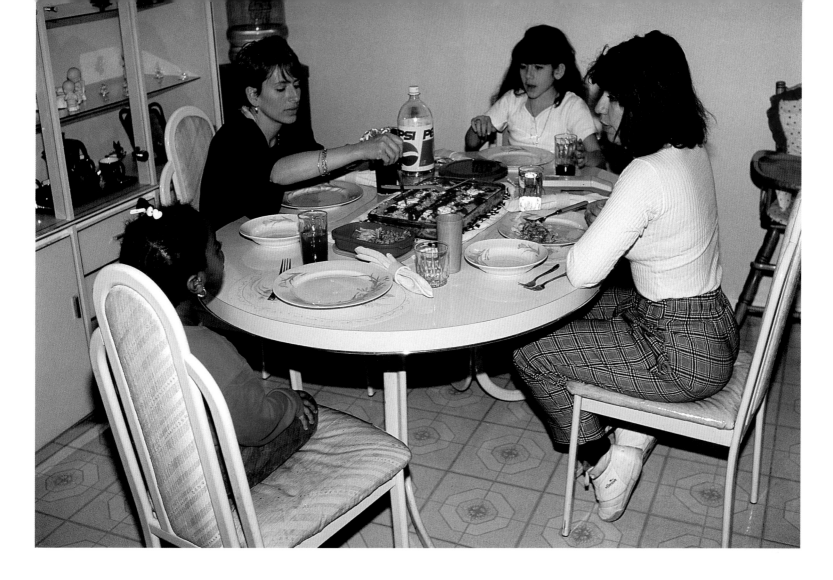

Tonight's dinner will be easy and delicious. This morning, Sara's mother came to prepare one of her fabulous lasagnas. All Sara has to do is pop it into the oven.

Sara's sister Maria comes home from work and lends a hand. Her apartment is just a few steps away from Sara's. Soon after Maria's arrival, the doorbell rings. A little girl who lives down the hall asks if she can play with Jennifer while her mother does some shopping. Sara invites her to join them for dinner.

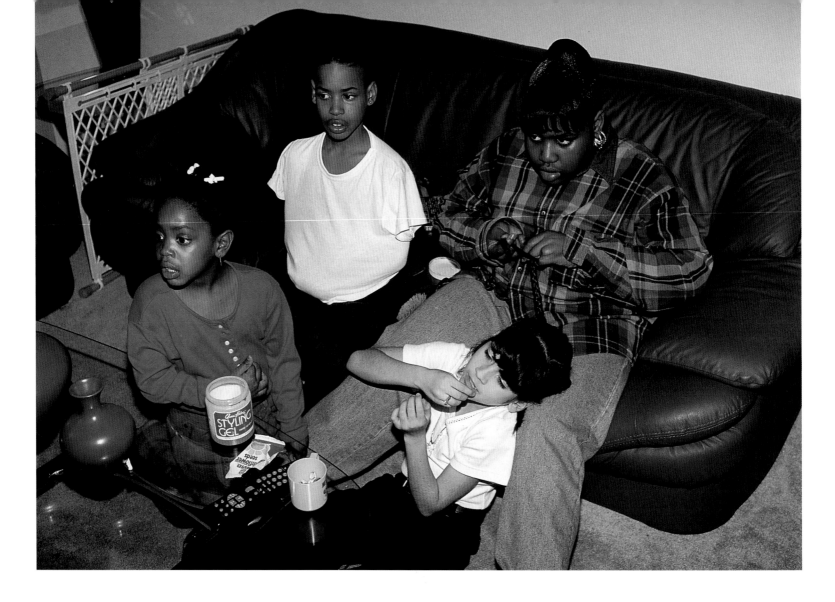

No sooner is dinner finished than the doorbell rings again. This time, it's the girl's big sister, Trina, and her brother, Tracy, who have come to hang out. Sara loves to open her home to family, friends, and neighbors.

Jennifer sprawls in front of the big TV screen, munching sunflower seeds. Trina braids her hair while they all settle down to watch a horror video on the VCR.

Anthony comes home later than usual. Every night, he kneels at his bed to say his prayers. Anthony believes that if he prays hard enough, God will make his mother better so that nothing bad will ever happen to her. Sara has her doubts, but she would not spoil her child's faith.

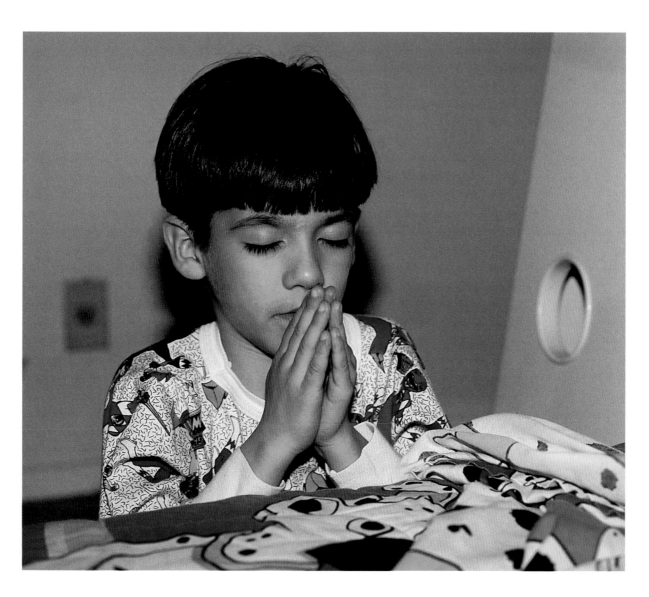

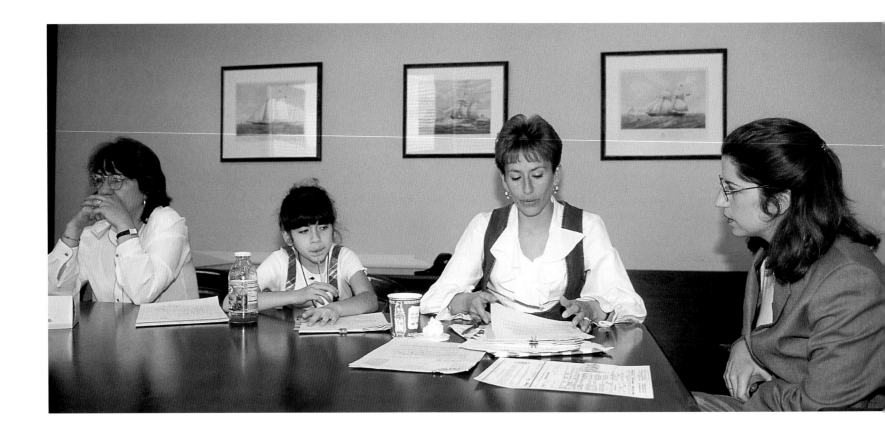

For a long time, Sara has struggled over the decision to assign a legal guardian for her children. At twenty-nine, she feels too young to die, yet she knows her chances for a long life are slim. Her mother, Ramona, is a responsible, loving person. But she's also an old-fashioned woman. Sara worries that when she is gone, her mother will never discuss sex, AIDS, drugs, or juvenile crime with the children as Sara has done. Nevertheless, as Sara signs the documents her attorney has prepared, she is relieved.

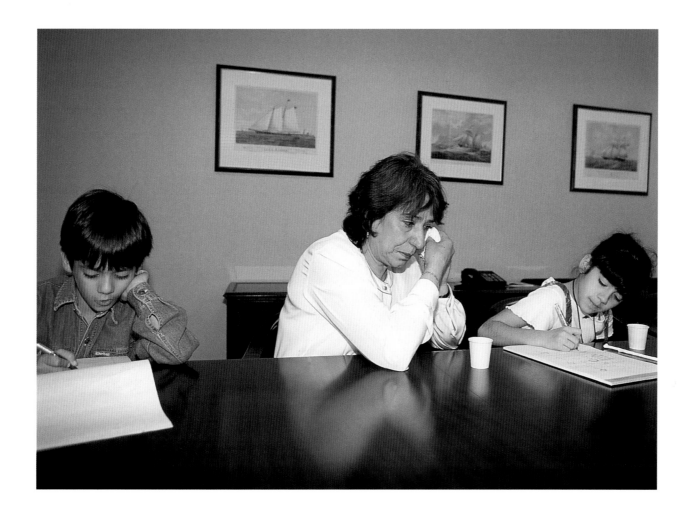

They have agreed that when she dies, her mother will take over her apartment so that the children won't have to move or change their school. Sara's insurance policies will cover their maintenance. Ramona cannot control her weeping at the thought of losing her youngest daughter—her "baby." But many single mothers with advanced AIDS are desperate to find caring guardians for their children. Sara doesn't have this problem. At least in that respect, she is lucky.

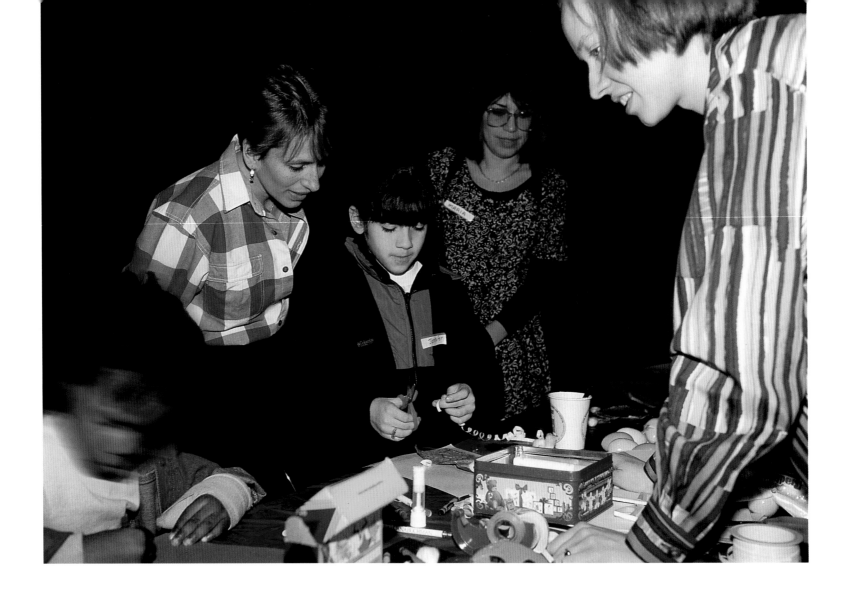

In April, the Child Life program throws a big Spring Bunny Party. Hosting holiday parties is one of the activities of GMHC, which has helped many families like Sara's. These parties are arranged to bring joy and some fun into the lives of children and parents with AIDS. There's lots of delicious food, arts and crafts, games, and entertainment for everybody. Anthony runs off to play with the other children. Jennifer heads for

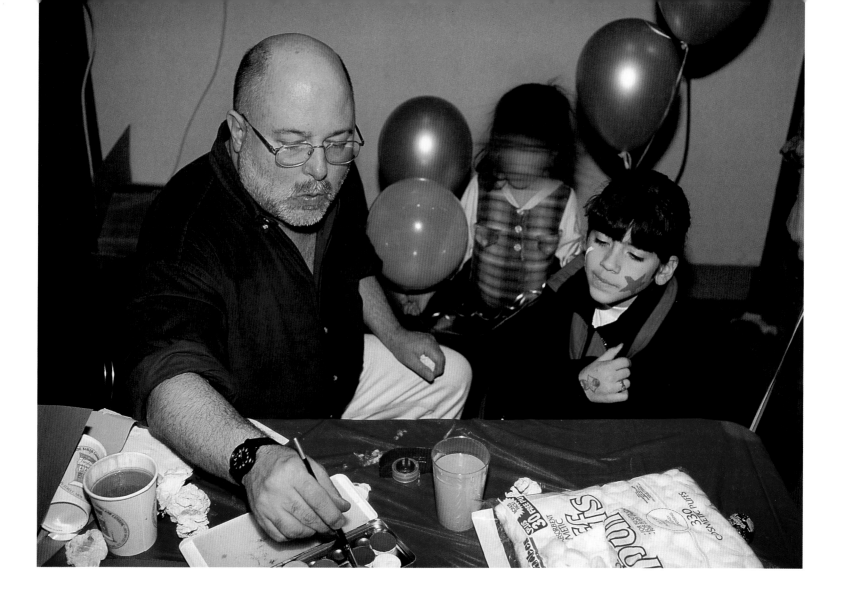

the arts-and-crafts tables with her mother and Aunt Maria. She has also got her eye on another table where there is a long, long line of kids waiting to get their faces painted—she can't resist!

The faces of the other children in these pictures have been blurred on purpose so that no one can recognize them. This is to safeguard the identities of people with AIDS and to protect their families against discrimination.

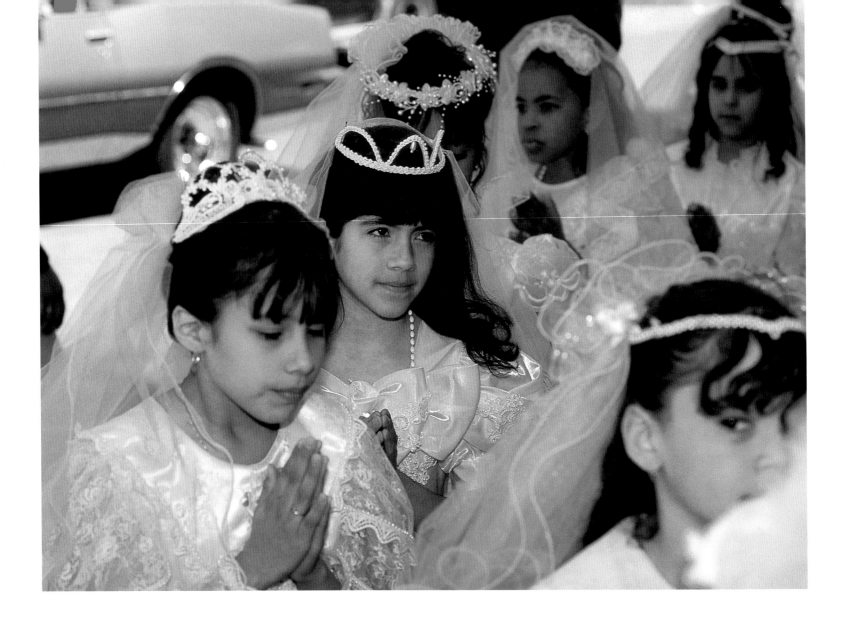

Although Sara isn't especially religious, she wants her children to learn about the Catholic faith they were born into. This may comfort them when she is gone.

Today, Jennifer will take her first Communion. As she enters the church, she is nervous but thrilled with her beautiful white dress.

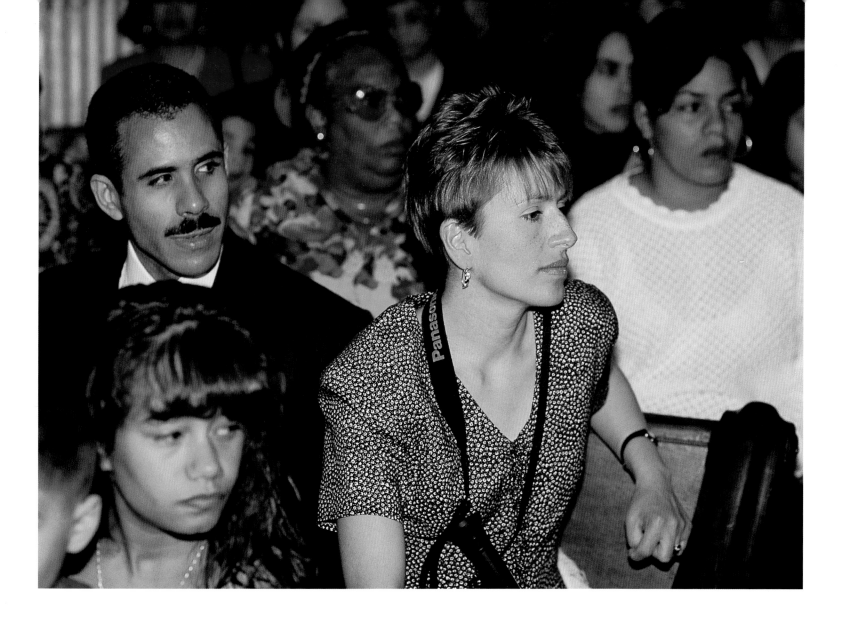

Inside, proud parents crowd the pews. Sara looks wistfully at her daughter. More than anything, she would like to see Jennifer happily married and proud of her own children one day.

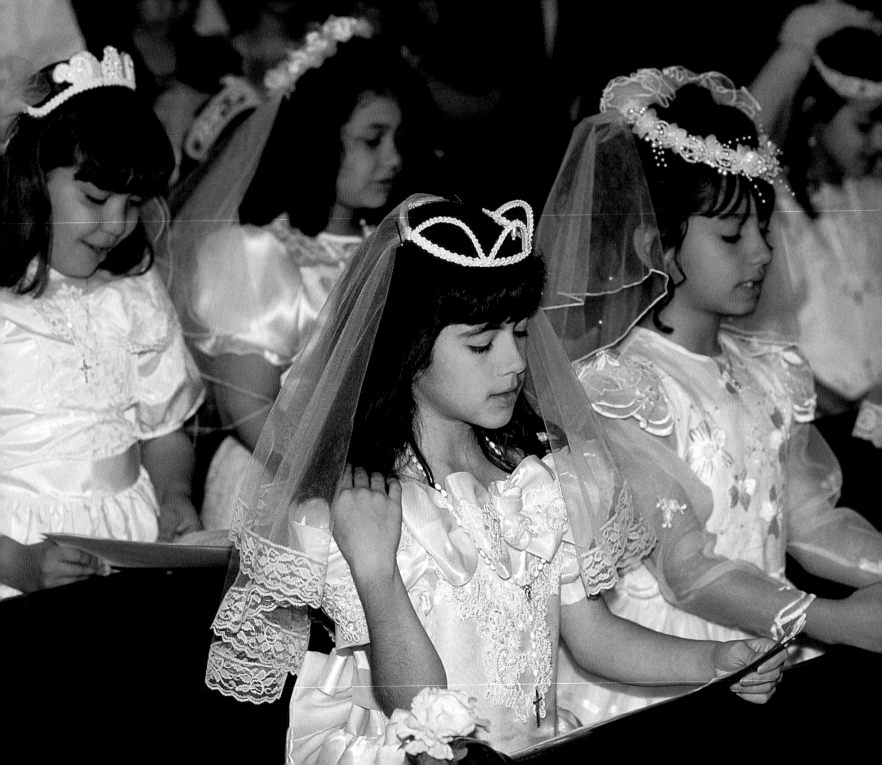

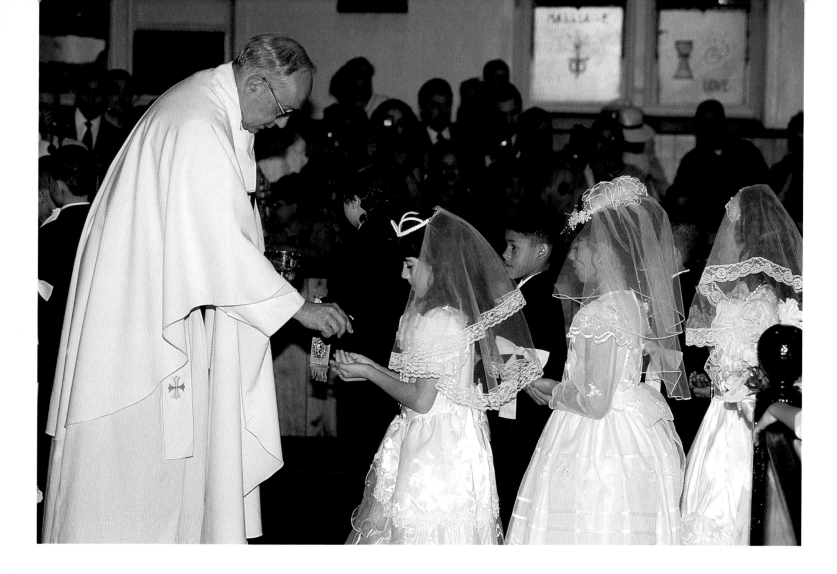

The priest raises a goblet of consecrated wine and recites the Blessed Sacrament.

The young girls solemnly repeat the words. Then they file past a nun who gives them each a sip of wine, the blood of Christ.

Finally, the priest places in each girl's hand a thin wafer of bread, the body of Christ, which she puts on her tongue. Now, and for as long as they practice the Catholic faith, they will go to confession and receive this Holy Communion with the Lord.

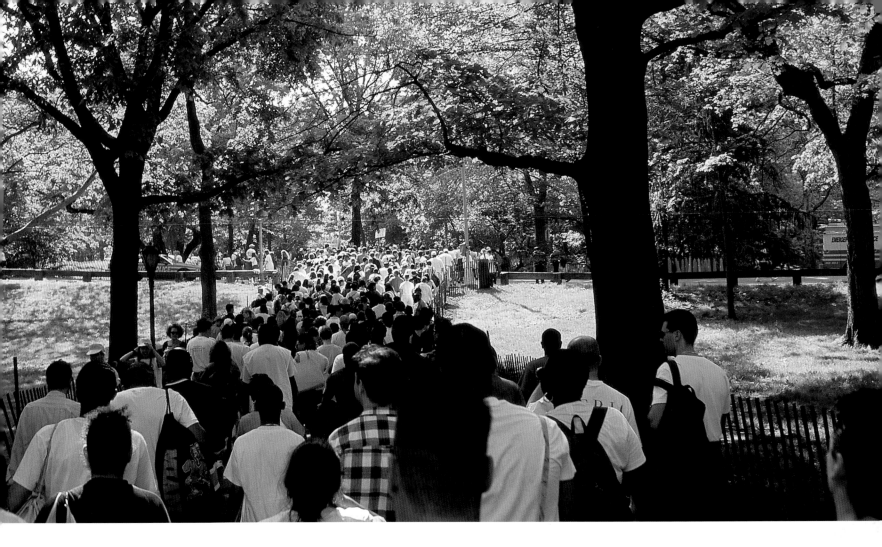

Since 1985, GMHC has organized an annual "AIDS Walk, New York." The walk's purpose is to raise badly needed funds for GMHC's wide range of services to thousands of victims throughout the city. Sara has participated in this important event for six years.

Early in the morning, on May 21, a vast column of New Yorkers stream into Central Park. Sara is accompanied by her sister Madeleine and her children. They are heading for the park's Great Lawn. Tents have been set up there for volunteers who are helping with registration forms and giving receipts for donated checks.

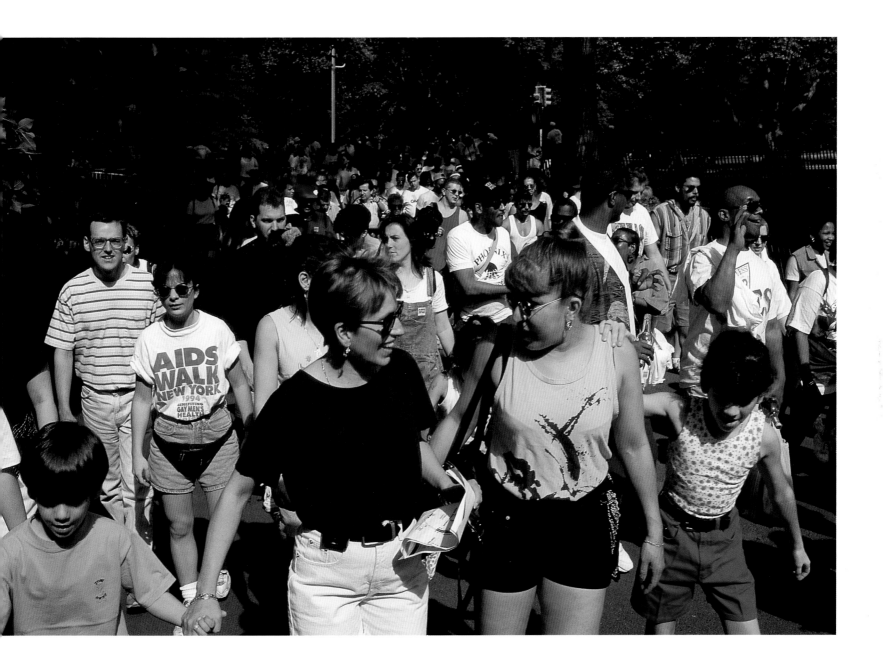

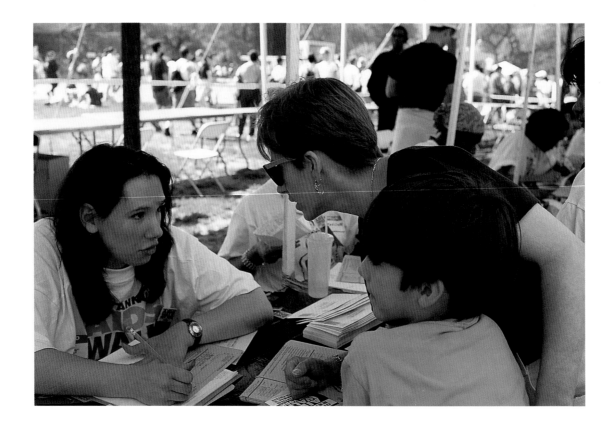

After completing her registration, Sara asks for directions to the NYNEX group's station. Major corporations sponsor groups of employees who participate in this walk. They make contributions to the AIDS cause. Sara wants to walk with some of her former fellow employees. She and Anthony are given T-shirts with the company's logo. Anthony's shirt reaches almost to his ankles.

Sara's group has formed and is ready to begin the ten-kilometer walk around the park. The participants cheer and yell encouragement to one another. Every race and age group is represented among the 31,000 people amassed here. By the end of the day, more than four and a half million dollars will have been raised for AIDS, history's deadliest plague.

Today, there are over half a million AIDS sufferers in America, with at least 300,000 deaths so far. And yet, since its first appearance in 1981, the U.S. government has remained oddly uninterested in protecting its citizens against this threat to their lives.

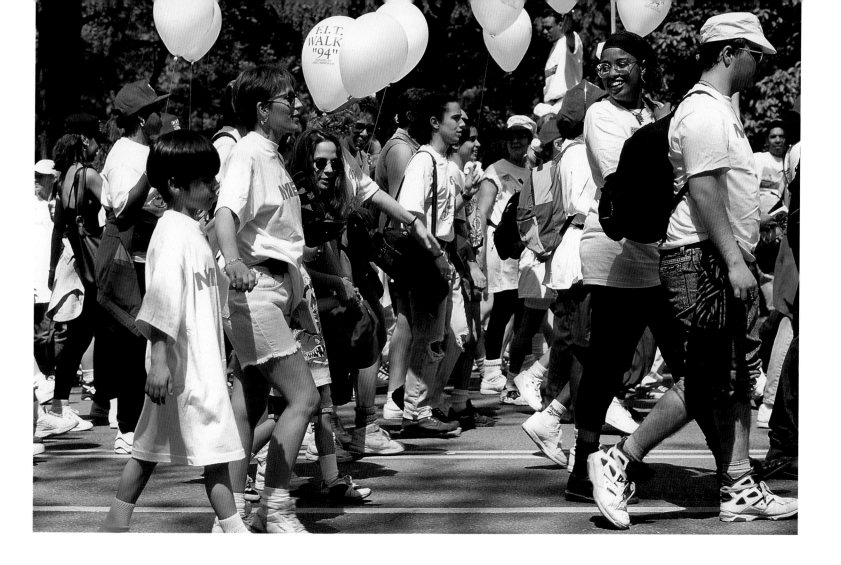

Too many of those marching here have lost close friends, relatives, husbands, wives, lovers, business associates, and children to AIDS. Many others are afflicted with it themselves. Strangely, their faces reflect love and fellowship rather than despair. And so it is with Sara. In some rare victims, the destructive advance of the virus has come to a mysterious halt, allowing them to live normal, active lives. Perhaps Sara will be one of the lucky ones. But for now, she is living her life as fully as she can, one day at a time.

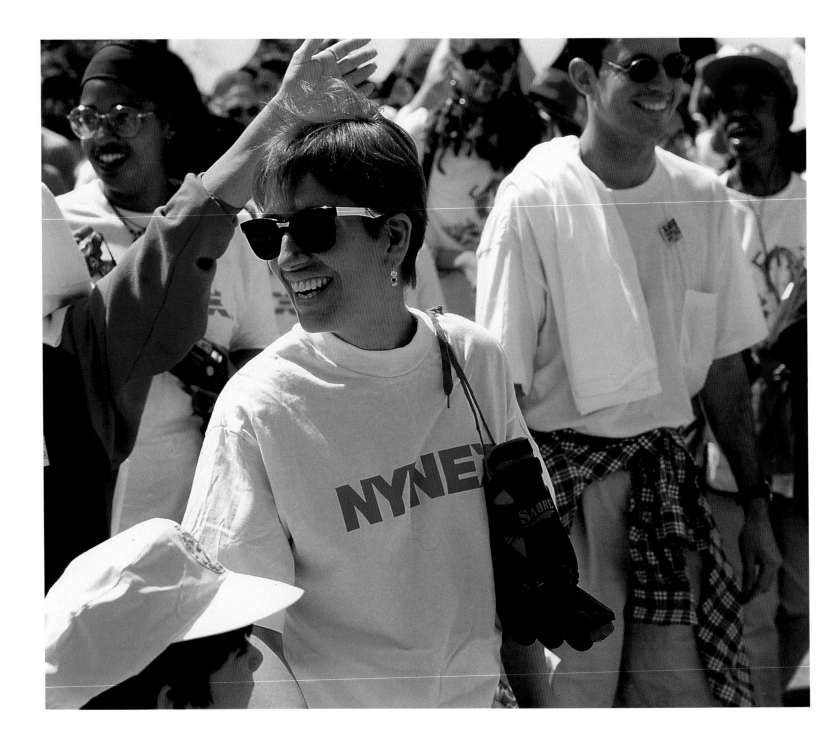